REMEMBRANCE

OF THINGS PRESENT

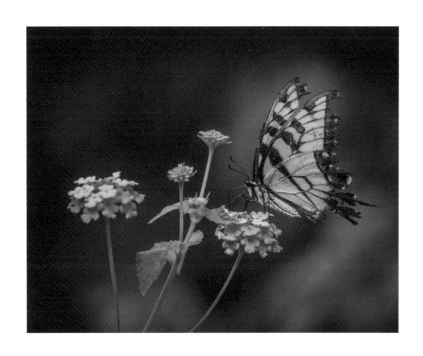

REMEMBRANCE

OF THINGS PRESENT

Making Peace with Dementia

text and images by

PETER MAECK

Shanti Arts Publishing

Brunswick, Maine

Published by Shanti Arts Publishing

Shanti Arts LLC
193 Hillside Road
Brunswick, Maine 04011
shantiarts.com

Printed in the United States of America

ISBN: 978-1-941830-80-2 (softcover)
ISBN: 978-1-941830-84-0 (digital)

Library of Congress Control Number: 2017938105

for Gabriel and Antonia

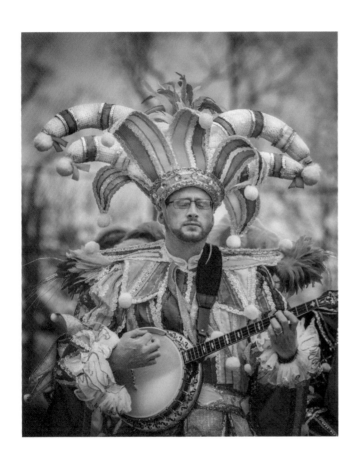

. . . the old Berlin — last vestige of a mysterious fête — wheeled away from the gravelled road and went lurching noiselessly across country over a grass-grown track. Beyond the hedge nothing could be seen of it but the driver's cap bobbing up and down.

— Alain-Fournier,
Le Grand Meaulnes, 1913

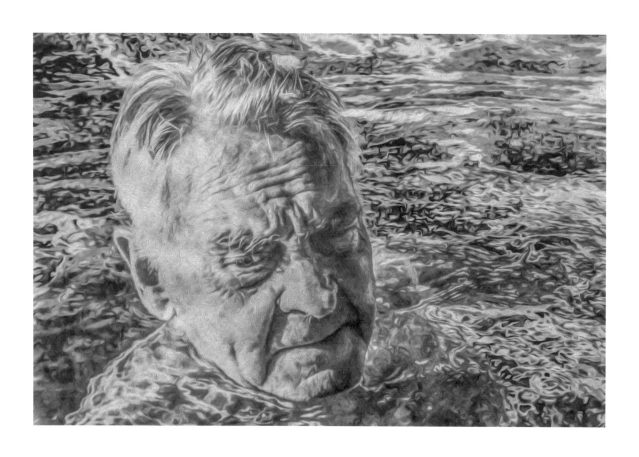

INTRODUCTION

When my father was diagnosed with Alzheimer's disease, I tempered my shock by denying this was a tragic turn of events. Hey, I decided, this is a gift! Dad will be relieved of the haunting ghosts of the past and the looming demons of the future. He'll live in a blissful "Here and Now;" we should all be so lucky!

The Kübler-Ross model says denial is the first of the five stages of grief. Denial numbs our pain, or at least deflects it. But while I was grieving my father's condition, I wasn't denying it. In fact, I'd quashed my grief by celebrating it.

But this was a vain approach. I found that as I observed my father and other Alzheimer's patients in various moods and states of health, I couldn't

really tell where they felt themselves to be in a time continuum. And I worried for myself: was dementia in the blood? Would I someday lose my own memory? Now I wasn't celebrating; I was trembling from fear and a weird kind of rage.

If anger is the second stage of grief, I guess I was in it. What was I angry at though? Cold, cruel fate? No, that was too vague. I needed an enemy I could see, talk to, attack. And so I took aim at dementia itself.

When I teach playwriting, I write on the board: DRAMA IS CONFLICT. I explain that to live and breathe, the drama must be personified: Protagonist versus Antagonist. In the play I was living with my father, dementia was my personal antagonist. "Damn you, Dementia," I cursed, "have you no shame?"

But really, dementia feeling shame? Who was I kidding? And who was I kidding that dementia could be defeated?

The third stage of grief is supposedly the bargaining phase. But there was no bargaining with dementia. And I began to realize that the antagonist I'd been fighting was myself, my own wishful presumption that Alzheimer's patients live in a blissful and eternal present tense. I had slid straight toward grief's fourth stage: depression.

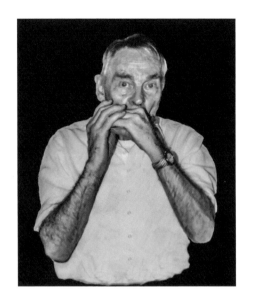

To check my slide I picked up Dad's old harmonica but put it down after blowing a few random, discordant notes. Dad then took the harmonica himself, touching it and looking it over like a child rediscovering a long-lost toy. "You used to play," I said to him, sadly. "Oh, how you used to play." Whereupon he put the instrument to his mouth and played note-perfectly and with brio "The Old Oaken Bucket," which he'd learned as a young boy. I watched and listened in silent amazement for several moments, then I began singing along:

How dear to this heart are the scenes of my childhood
When fond recollection presents them to view!
The orchard, the meadow, the deep tangled wildwood,
And ev'ry loved spot which my infancy knew.[1]

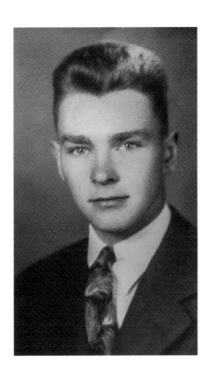

In his youth my father had had a prodigious memory. He'd amazed his hometown by memorizing and reciting Robert Browning's complete "The Pied Piper of Hamelin" — 303 lines, 2,432 words — at a school assembly.

"Remember that poem?" I asked Dad now.

"Rats!" he replied instantly . . .

They fought the dogs and killed the cats,
And bit the babies in the cradles,
And ate the cheeses out of the vats,
And licked the soup from the cooks' own ladles,
Split open the kegs of salted sprats,
Made nests inside men's Sunday hats,
And even spoiled the women's chats,
By drowning their speaking
With shrieking and squeaking
In fifty different sharps and flats.

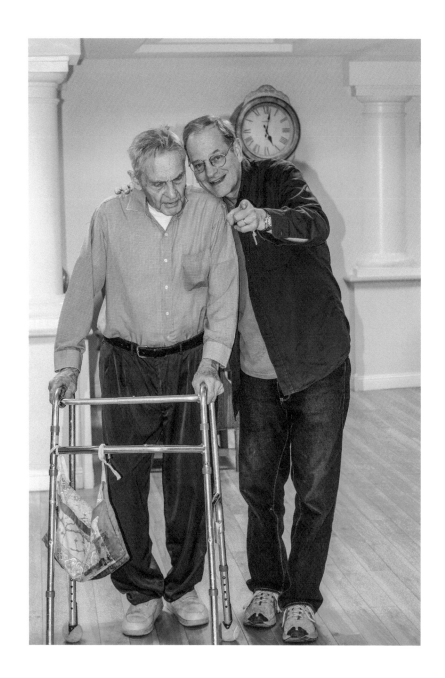

There's an old Sanskrit word, *lila*, that means play, or more specifically, divine play. *Lila* creates, destroys, and re-creates all reality. In this both human and cosmic sense, *lila* means playful joy in the present moment. It also happens to mean love.

In his wonderful book *Free Play*, Stephen Nachmanovitch calls *lila* the key to reviving our sense of wonder in the world. Through it we can return home to our open-hearted and open-minded true selves.[2]

I began thinking that homecoming to our true selves might be a coming home from bemoaning half-empty glasses to accepting half-full ones; from micromanaging life in our logical left brains to embracing life in our intuitive right brains; from being rigidly anti-biotic to more naturally pro-biotic; from fighting affliction to nurturing health. We would become playful, more so every day, and as we grew older, we'd rediscover our youth.

"You remember that poem 'Jenny Kissed Me?'" I asked my father. "Jenny kissed me when we met," he said immediately . . .

Jumping from the chair she sat in,
Time, you thief, who love to get
Sweets into your list, put that in!

Dad could never recite that poem without his eyes moistening.

Say I'm weary, say I'm sad,
Say that health and wealth have missed me,
Say I'm growing old, but add,
Jenny kissed me.[3]

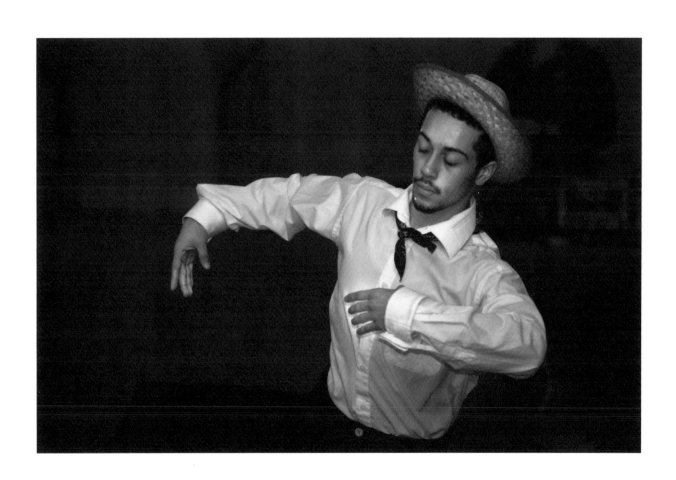

I'm a photographer as well as a writer. Having taken many pictures of young people, I now began focusing on my father and other Alzheimer's patients. I felt that instead of trying to guess at these people's mental states, I'd do better just photographing them, capturing them in eternally present-tense images that would last longer than they or I would.

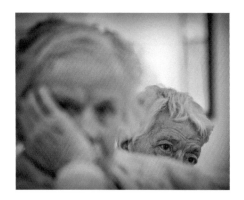

Now as I look over these pictures of young and older people side-by-side, it strikes me that while youth connotes exuberance, joy, innocence, and adventurousness, certain physical attributes of young persons suggest the presence of nascent adult behaviors and states of mind. I see that the line from youth to late adulthood, while often obscured by time and varieties of experience, can nevertheless be perceived as unbroken, especially in photographs that present early and later stages of life as distant mirrors of each other. And I see that this lifeline isn't always straight and in the same forward direction. Sometimes, having caught older people at play, I see that the line loops back to youth.

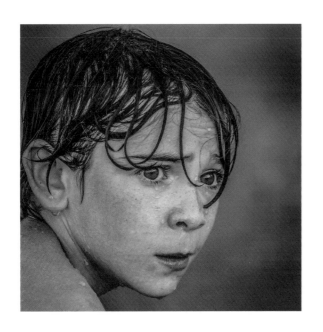

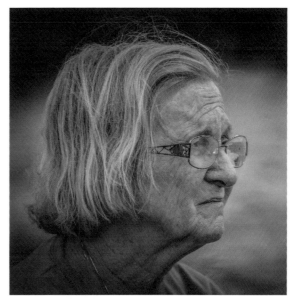

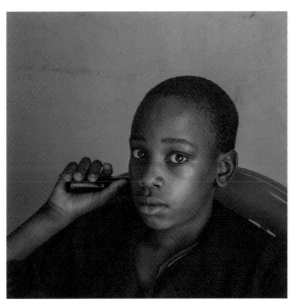

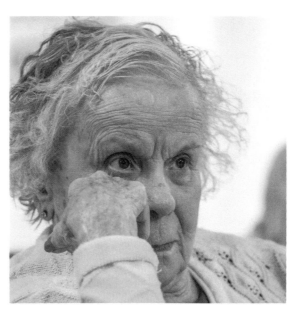

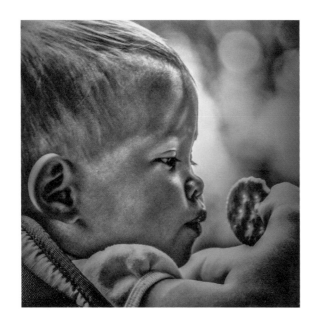
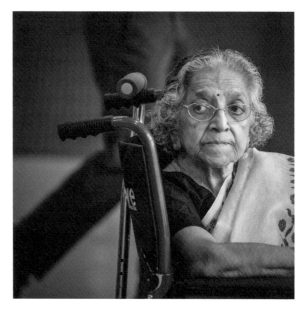
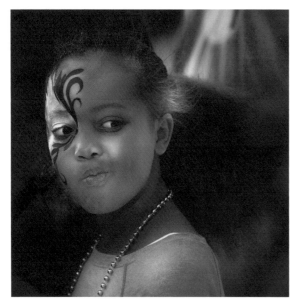
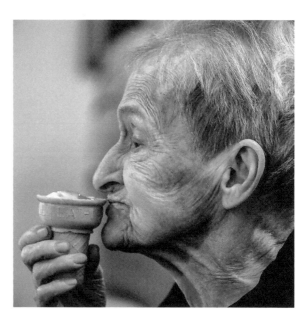

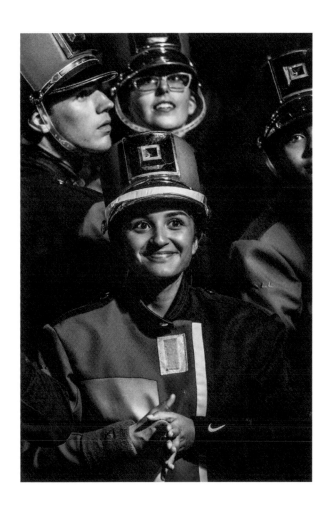

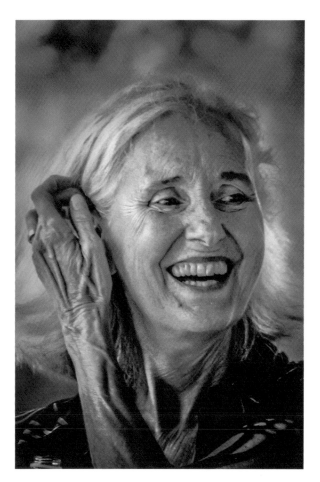

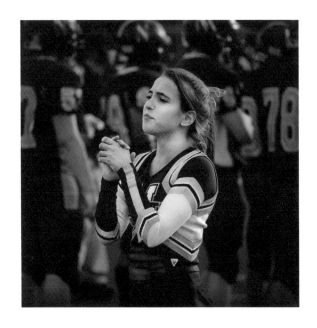

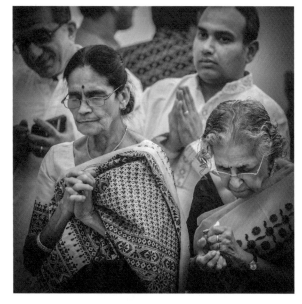

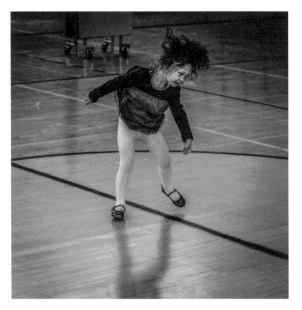

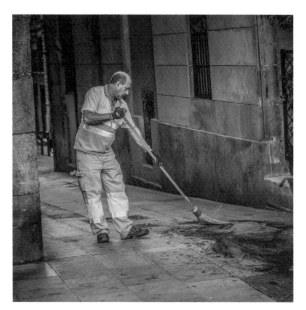

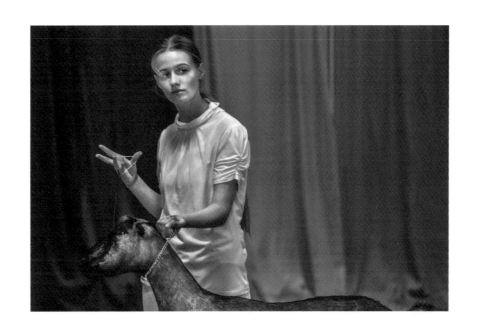

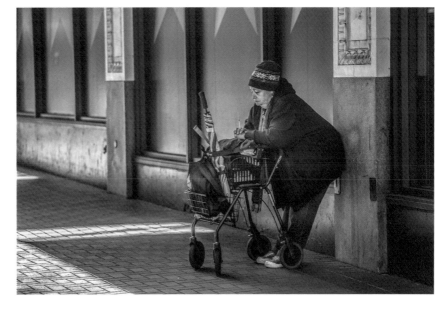

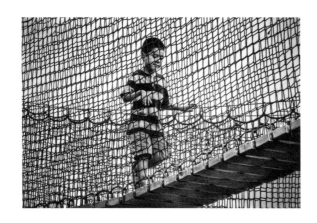

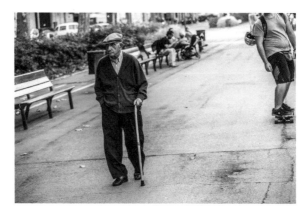

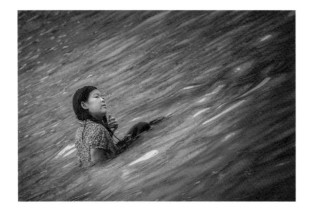

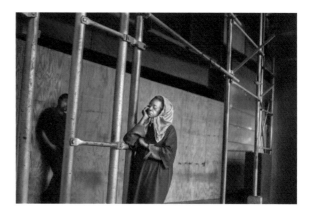

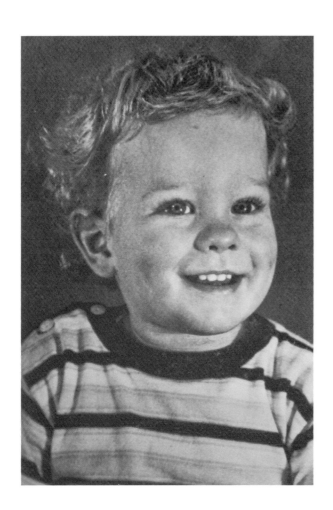 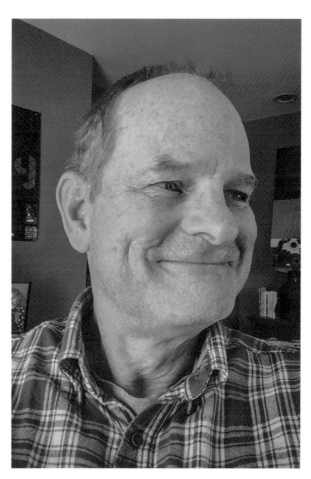

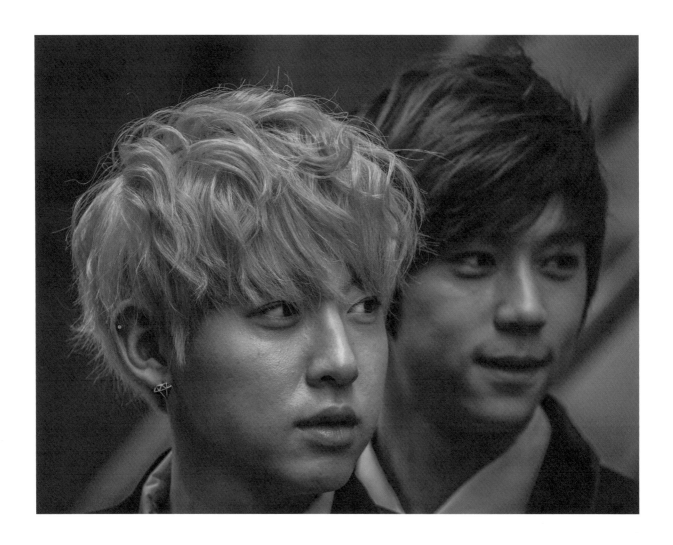

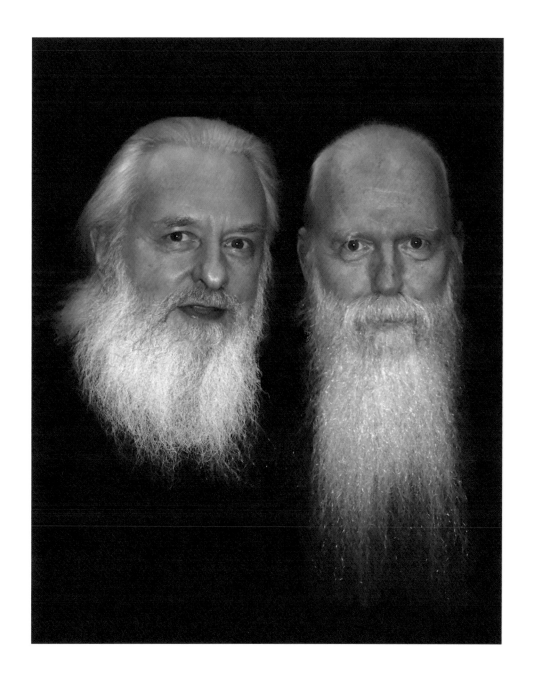

Viewed as a biological deterioration of the brain, Alzheimer's disease is terrifying, smelling of rot and decomposition. There's another way to see its biology though: as fermentation, in which organic matter is not spoiled but transformed, as are grapes into wine, and milk into cheese.

In his book entitled *Cooked*, Michael Pollan cites Samuel Taylor Coleridge's "secondary imagination" that "dissolves, diffuses, dissipates, in order to re-create." Pollan likens this breaking down of ordinary consciousness to the wine-*making* process, in which yeasts break down plant sugars to create something more potent and stimulating; and also to the wine-*drinking* process, which in moderation, can produce a less literal and more metaphorical perspective: poetry, for example, in place of prose.[4]

In this very way, while my father had Alzheimer's, he and I moved from a prose relationship into one of poetry, which was no better or worse, just different, less literal and more metaphorical. We engaged more in rhyme than in reason, freezing time initially but then melting it and coming together in that lyrical middle realm between what had gone before and what was yet to be. It felt to me like grief's fifth stage of acceptance, and I think to him also, as he lived his last days, and died, in a state of peace.

— Peter Maeck

1. Poem "The Old Oaken Bucket" by Samuel Woodworth (1817) was set to music by George F. Kiallmark (1826).
2. Nachmanovitch, Stephen. *Free Play: Improvisation in Life and Art*. Los Angeles: Jeremy P. Tarcher, Inc., 1990.
3. "Jenny Kissed Me" by Leigh Hunt (1838).
4. Pollan, Michael. *Cooked*. New York: The Penguin Press, 2013.

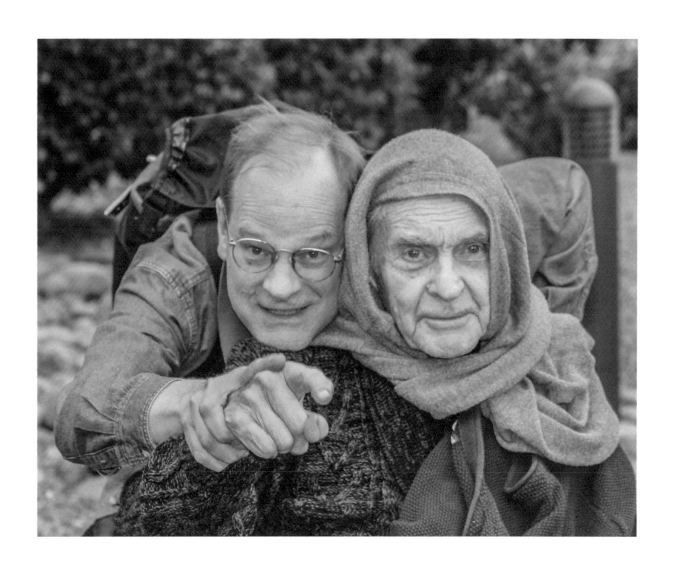

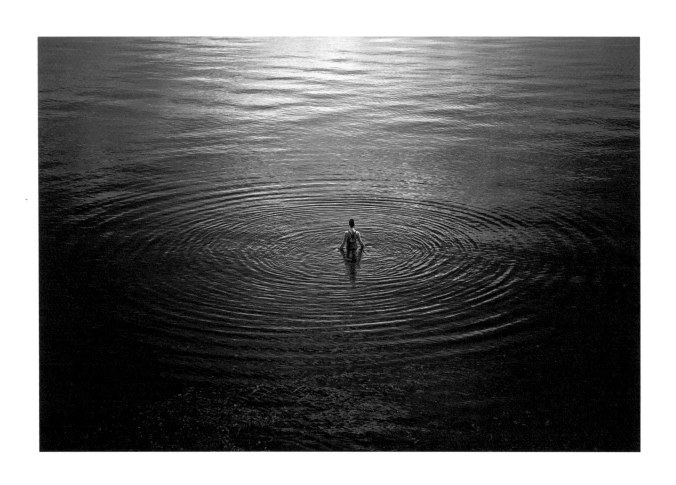

Remembrance of Things Present

Dementia is a sorry state:
It robs you of your memora.

You never know the present date,
The past becomes ephemera.

The future lies ahead, they say,
Tomorrow is another day.

They lie: tomorrow's blush and glow
Remain no longer than the snow

Which melts in spring as days grow longer,
Warming as the sunlight's stronger.

In the ardor of those rays,
Tomorrow's name becomes today's.

You live from now 'til all time hence
In a constant present tense.

Maybe that's all right, my dear,
Forgetting all you used to fear:

Present dangers, future shock,
Ancient traumas. Stop the clock!

Bend down, breathe in, and smell the roses
Blooming just beneath our noses.

Fill your nostrils, inhale deep,
And pray the lord your soul to keep.

Or if, like me, you'd rather pray
To mountains or a well-made play,

Or if your spirit soars aloft
Less in a pew than in the soft

Embrace of samba, or perhaps the call
Of temple bells in Parsifal,

You'll join me singing hymns in winter
To the ghost of Harold Pinter.

Then we'll praise George Balanchine,
The saffron thread, the coffee bean,

Picasso, Chekhov, Frank Lloyd Wright,
McCartney, Lennon, Three Dog Night.

All you fans of opera buffa,
Make some room for François Truffa.

Sit ye down and take a *leçon*
From *cher* Monsieur Cartier-Bresson.

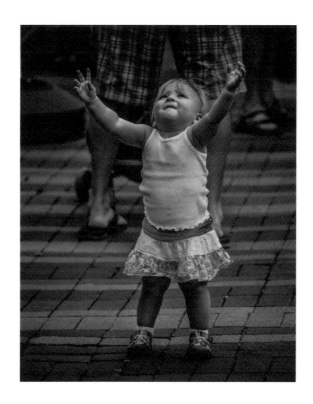

Sip the wisdom of Spinoza,
Gorge on shumai, gobble gyoza.

Sing the "Ode to Joy" in German.
War is hell, said General Sherman,

Leaving out that what is worse
Is when your taxicab's a hearse

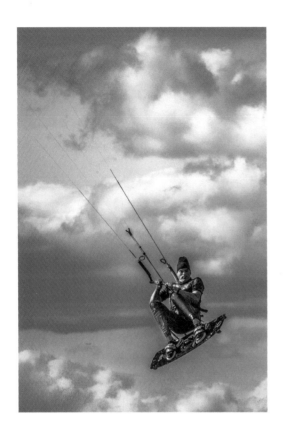

Whose meter runs forever mo'
Like ravens call in verse of Poe.

This taxi to the dark side runs
A thousand not so splendid suns

Beyond the far horizon then
Comes round again once more times ten,

Times ten, times twenty, never halting,
Skidding, spinning, somersaulting.

You forgot your seat belt buckle,
Now this ride's the worst white-knuckle

Flight you've ever taken and you're sick,
Not knowing if you're dead or quick.

You only want to leave this jitney,
Never mind the awful litany

Of the wherefores and the whys
You've entered such unfriendly skies.

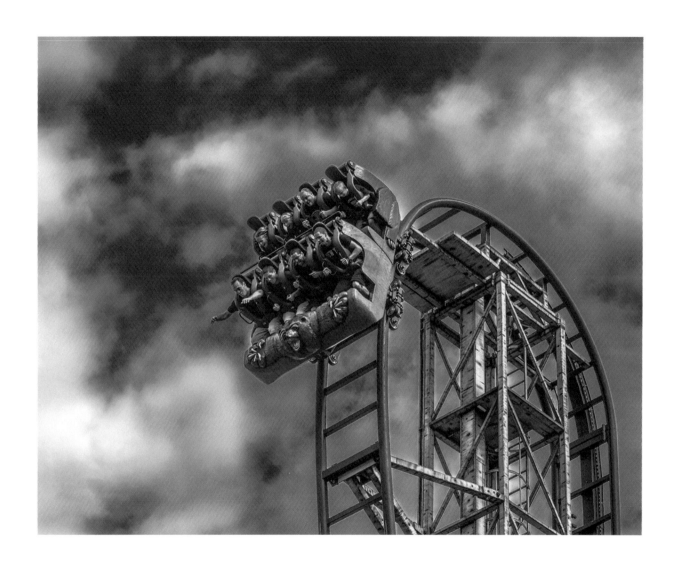

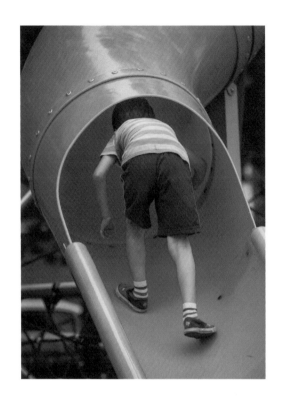

Well, let me set you wise:

You should have walked.
Or better, not set out
Where there be monsters
Round the nearest bend
And up the dented, dripping water spout.
I mean you could have stayed at home.
By home I mean within the confines
Of the current day, this hour,
Where time relents, pulls up,
Falls in, and stands in line,
Presenting arms, eyes right, eyes
Left behind, no longer looking out
Ahead, nor back, but deep within . . .

At that which all the time reminds us,
Glory isn't quite behind us

Yet. Nor is it out so far ahead
We only taste it when we're dead.

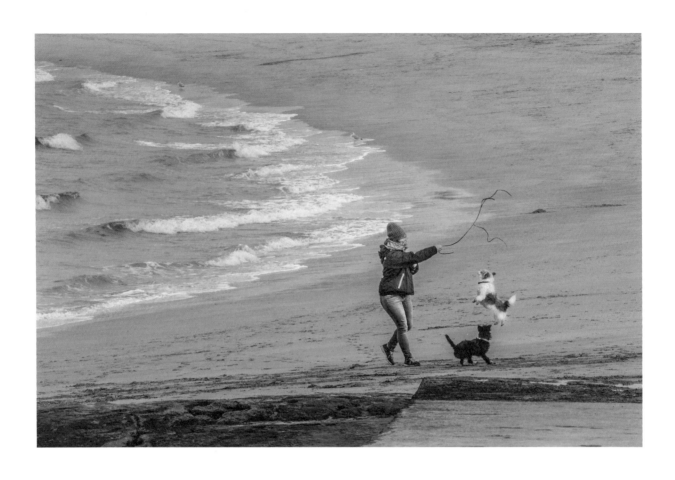

Berlioz, Beethoven, shrimp on the barbie,
Cabernet Sauvignon, classic guitar. Be

Of cheer, be of mirth, *carpe diem*, I say,
Which in Latin exhorts us to grab hold the day

By the short hairs, wherever those short hairs may be.
String it up by its neck on the branch of a tree,

Then go wailing and whacking the stuffing right out
'Til that *diem*'s so *carpe*'d it can't even shout

That there's more to be savored. The truth is there ain't:
Not a cell nor a feather. Now wait, I feel faint.

I am suddenly touched by the darkest suspicion
That all that I've said is just wishfully wishin'

That losing my mem'ry is God's plan for me
When I don't even think there's a God in the sea,

Or the sky, or on land in a chariot riding.
Dementia's a bitch, and there's no use in hiding

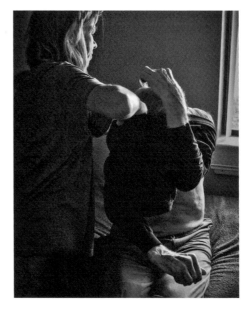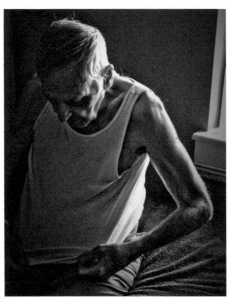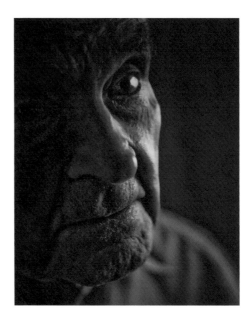

The truth that it's no gift sent down from on high,
Or that present sensations suffice — that's a lie.

What gift takes away all we've treasured in life?
Erases our husband and blots out our wife?

Makes the children we've raised and protected from dangers
Come before us not loved ones but absolute strangers?

So easy for those not demented as yet
To so flippantly say, *You're demented? Don't fret.*

All that milk that you spilled is now washed 'neath the bridge.
If you're wanting more milk, well there's more in the fridge.

And if it's tomorrow that has you akimbo,
Relax, for tomorrow is wafting in limbo,

Remaining that way, out of reach, out of mind,
Just as yesterday's flown, so you're not in a bind

Between future and past. No, you're in that sweet spot
Where the steak always sizzles and tea's always hot.

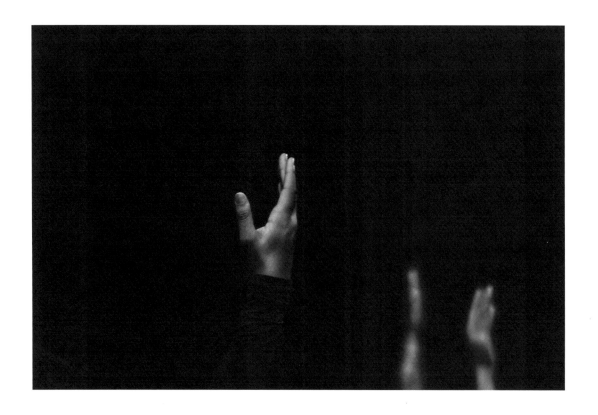

That place is the present, be thankful you're in it.
Go down on your knees, say a prayer every minute

Of thanks to the glorious powers that rule!
Who've embalmed you in amber, you high holy fool.

You're pickled, flash-frozen, all wrapped up in gauze.
Your clock has been stopped against all natural laws

Which allow you full freedom to raft and to row
On the river of time, let it flow, let it flow,

Let it flow, to the dams which obstruct rushing streams,
Back them up 'til they flood ancient towns, ancient dreams,

Making lakes in the valleys where flowers once bloomed.
Stupid flowers didn't know their existence was doomed?

Be Here Now, Smell The Coffee, and other such tripe
Only drive the illusion, just generate hype

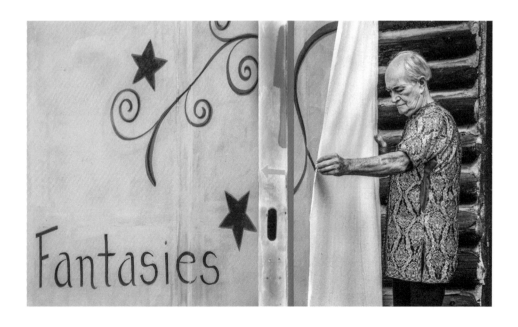

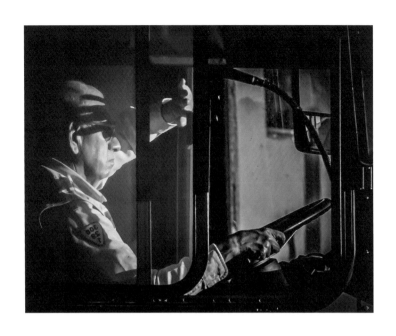

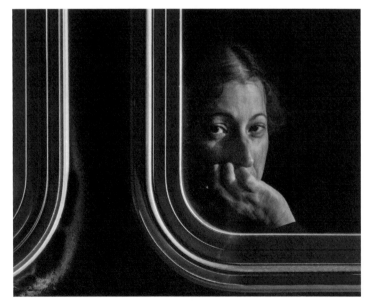

For the notion that what's going on this here second
Is better and finer than what we had reckoned

Were mem'ries so golden they'd never decay;
Would shine evermore in the light of the day.

But the day turned to night and we're missing a candle
To light our way backward. Oh, where's the damn handle

To lift off the lid of that old steamer trunk
Containing old albums which some would call junk?

They're not junk, they're the pictures of people we cherished.
Without those old pictures our loved ones have perished.

Give us this day and our daily bread, too,
But don't make believe that the world's born anew

Every morning. It's not, we're just one whole day older;
Wiser, we hope, and stronger and bolder.

Than what, though? Than yesterday? That we can't answer,
Except to affirm that dementia's a cancer

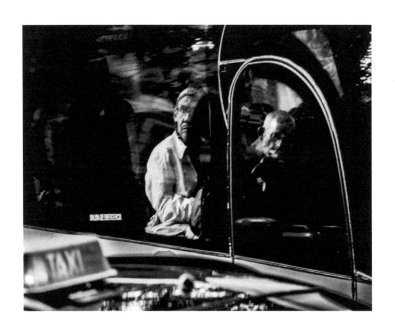

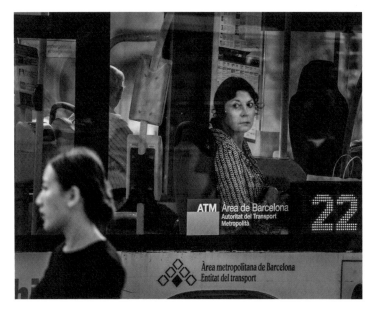

Which kills off our knowledge of which is more rotten:
A bad day remembered or one that's forgotten.

Saying it's moot is a cowardly ruse,
Denying that we'd rather keep what we lose.

Declaring dementia's a gift in disguise
Is like saying that Oedipus didn't need eyes,

And removed them because like a vestigial tail
They were useless. No, worse, as they one day would fail.

As if blindness were good 'cause we can't see the badness.
Well, missing the good causes ten times more sadness.

But I'm sounding bitter, my mem'ry's okay.
I know how to tell all the past from today.

I can't tell the future, but I have a notion
The sun will come up then go down in the ocean.

So why does dementia now make me see red?
Why can't I forget it and put it to bed?

You might as well try to forget your tax audit.
Forgetting dementia's a sure sign you've got it.

So I always keep it up front in my queue
Of things to remember, of things I must do.

As long as dementia stays top of my mind
It can never come bite me around from behind.

I stay vigilant, watchful, alert for attack.
I don't sleep 'cause in sleeping no one has my back.

It's just me with my knife and my guns and my pitchfork
Lest one night at dinnertime I forget which fork

To use for my salad, and which for my spud:
A sure sign dementia's wormed into my blood.

And soon as I can't find my car keys it's clear,
Dementia's arrived and my ruin is near.

But don't get too cocky, Dementia, you beast.
I'll bash and I'll slash and I'll wound you at least.

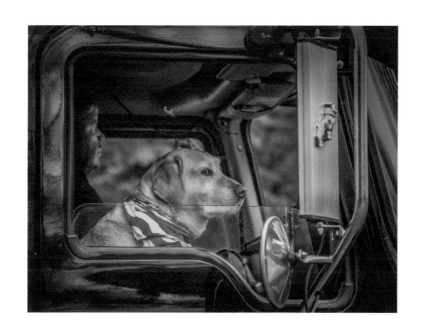

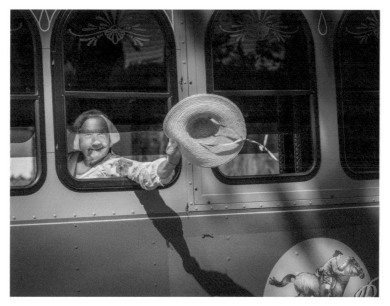

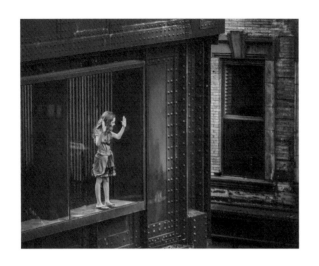

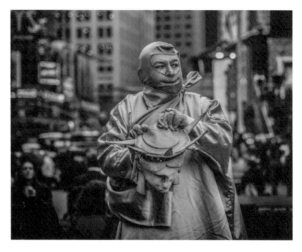

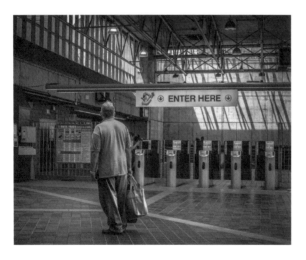

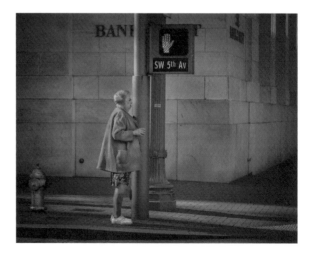

Though killing you won't be so easy, I know.
My dad couldn't do it, he'd little to show

For his efforts to keep his brain ticking apace.
It kept ticking, but slower, so you won that race.

I hope that you're proud, and I hope that you sing
When everyone's mem'ry unravels like string.

All of us losing our wits and our sanity,
All for the sake of your monstrous vanity.

Three cheers, Dementia, you've conquered humanity,
Now half-extinct like the beautiful manatee.

Count up your winnings, rake in your loot,
Take up your trumpet and give it a toot.

But know that a hell for afflictions awaits
You won't have your key for the white pearly gates.

You had it, remember? But then you forgot
Where you put it, and now you think: *Oh no, it's not,*

No, it couldn't be, could it? Dementia's set in?
But I am Dementia! I have no kin!

I am God, I am Allah, sui generis, unique!
Dementia demented? How dare you so speak?

And I will reply with a smirk and a laugh,
You think you're God? You're not God by half.

And Allah, I knew him, a good friend of mine,
But you are no Allah, you're not even swine.

But that insults pigs. You are scum, how is that?
You are scum's poor relation, you live in a vat

Of your phlegm and your bile and your other foul humors.
You bleed nitric acid, you vomit up tumors.

How vile can I get? Oh, much viler than this,
For you took my father, you stole his bliss.

And you say you gave him the best gift of all:
That he will no longer need be in the thrall

Of the past and the future, for present is he
In a Present eternal, a Now that won't flee.

That's nonsense, you know it, and I call you out.
The present is nice but it's nothing without

The surrounding dimensions of yonder and yore.
Heaven itself all the time might well bore

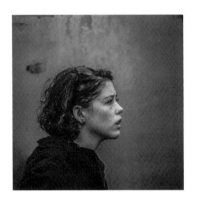

You to tears, but don't worry, you won't get the chance
To be bored where you're going, and I don't mean France.

They say Death Be Not Proud to the Reaper when he
Takes a man or a woman deserving to be

On this earth awhile longer. And I say to you:
Be Not Proud of dementing the people you do.

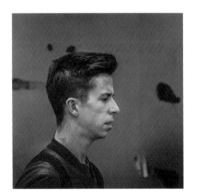

Be Not Proud anymore of the amyloid fibrils
You plant in the minds of both righties and liberals.

You're not a mad genius, you're none but a hack,
Tangling our neurons in jumbles of plaque.

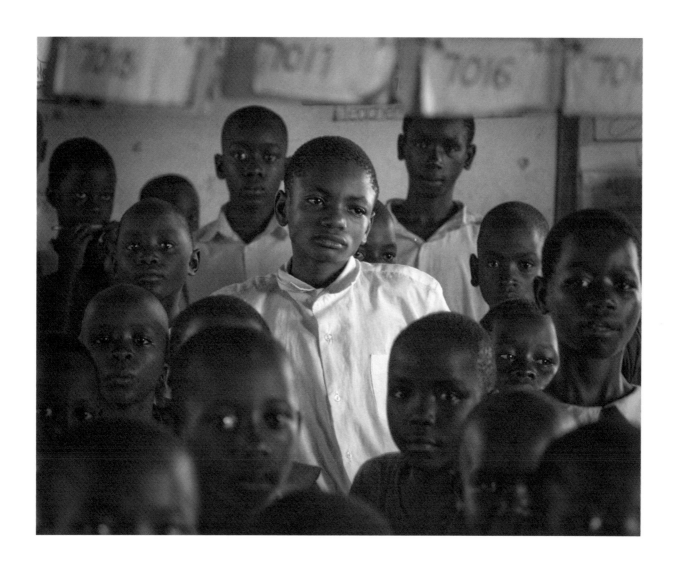

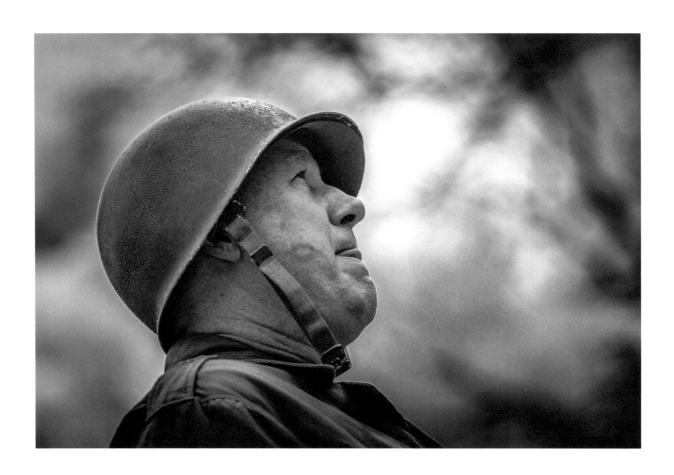

Be Not Proud of your talent for dulling our brains.
Be Not Proud on the day that forgetfulness reigns.

Be Not Proud of dementing good folks like my father.
Be shamed by your deeds! No, why? What's the bother?

No shame on your part will restore my old dad.
All he kept at the end was the love that he had

For his son and his daughters, the woman he wed.
But it trumps you, Dementia, this love in his head.

So does our love for him, and if you have the gall
To deny against evidence love conquers all,

Then you don't know what love is, how mighty and free;
How it floats like a butterfly, stings like a bee,

Leaping tall buildings at one single bound.
I once was lost, but now I am found

In the cradle of this of which you know not whereof:
It's love and it's us of which it takes good care of.

Who takes care of you? No one, that's the trouble.
And you know how it hurts me to burst your pink bubble,

But you are alone and your heart has absconded,
While we are united in love tightly bonded.

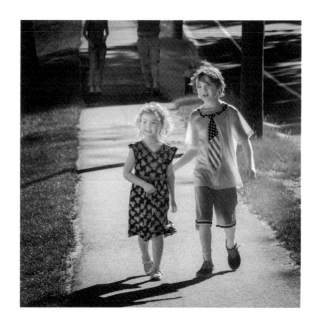

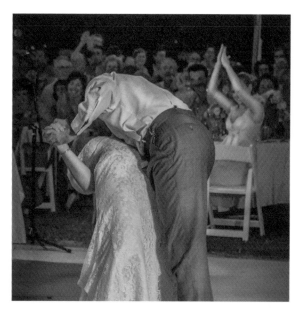

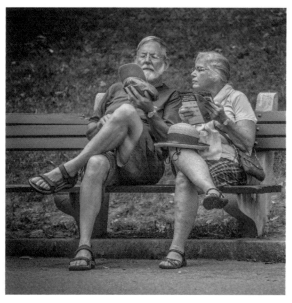

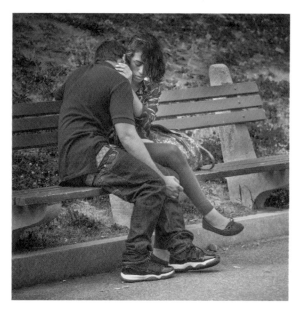

When winds knock you down we'll be standing up straight.
Being filled up with love we're the darlings of fate.

Whereas you're stuffed with Pride, wheresoever Pride goeth:
Before a hard fall, as soon you will knoweth.

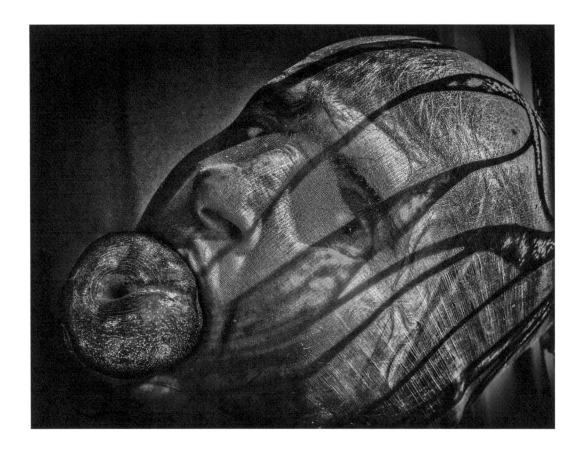

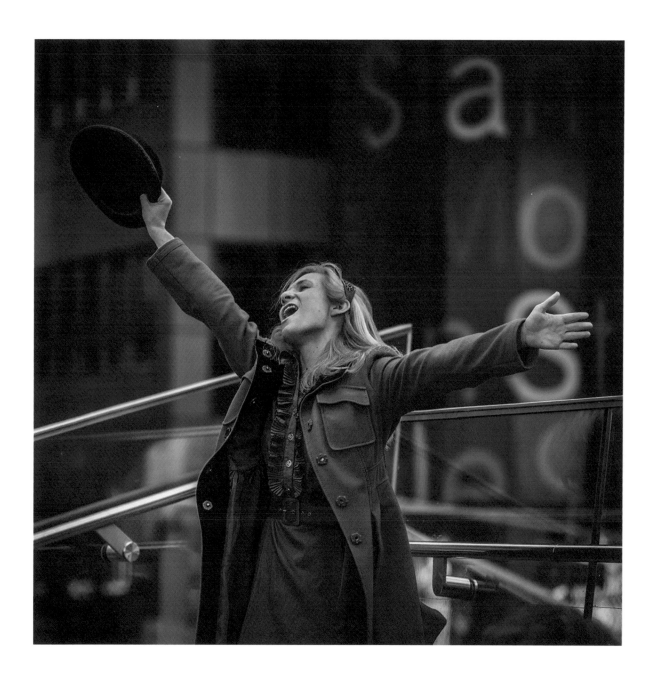

I realize my poem's a bit overwrought;
My metaphors strained and my similes not

So convincing at times, and my making dementia
A person whom I then destroy in absentia

Is really a stretch, but I'm just so high-wired.
No secret my poetic license expired

Last Tuesday and I can't renew it until
I am able to pay up my poetry bill.

But I can't pay my bill if I can't find my checkbook.
Could I be demented? No matter. Oh heck, look,

I've spoken enough, now I'll leave you to ponder
That down's sometimes up, and yore becomes yonder.

Don't fret past and future, just throw that old clock out.
When Dementia fights Love, Love wins by a knockout.

Peter Maeck is a poet, playwright, and photographer. His plays and dance scenarios, including for Pilobolus and MOMIX Dance Theatres, have been produced in New York City, Europe, and Africa, and his photographs have been exhibited internationally. Peter served as a U.S. State Department American Cultural Specialist in Tanzania and Morocco, and he has created training programs for major U.S. corporations. He holds a B.A. in English from Dartmouth College and an M.F.A. in Playwriting from Brandeis University. He has presented *Remembrance of Things Present* as a TEDx Talk in the United States and abroad. — www.petermaeck.com

William T. Maeck, Peter's father, was born in Shelburne, Vermont, in 1920. Educated at Northwood School in Lake Placid, New York, and at Dartmouth College, he was a public relations consultant, banker, skier, skater, musician, poet, husband, father, and wit. Though memory loss marked his last years, he never lost his good humor and gentle humanity. He died in Arizona in 2010.

CPSIA information can be obtained at www.ICGtesting.com
Printed in the USA
BVIW12n0151150417
481277BV00001B/1